BLACK & BOLD

Success inspirations from Baba Sala
for African Youths

Oyindamola Adejumo-
Ayibiowu (Phd)

Copyright © November 2018
Oyindamola Adejumo -Ayibiowu (PhD) All rights reserved.

No portion of this book should be used without the written permission of the Author. With the exception of brief excerpts in magazine, articles, reviews etc.

For Further information or Permission Contact:
Oyindamola Adejumo- Ayibiowu (PhD)
+234 802 327 7213
damolabiowu@gmail.com

ISBN: 9781099668906

DEDICATION

This book is dedicated to my late dad, my mum, my brothers, my sisters, Dabira, and my Afrocentric boss, Zakes.

CONTENTS

Title Page	1
Copyright	2
Dedication	3
Acknowledgement	7
INTRODUCTION	9
chapter ONE	13
Chapter TWO	16
chapter THREE	20
chapter FOUR	24
chapter FIVE	28
chapter SIX	39
chapter SEVEN	46
chapter EIGHT	50
chapter NINE	55

ACKNOWLEDGEMENT

My deepest gratitude goes to God for giving me inspirations to write deep revelations which I did not read from any book.

I also wish to express my gratitude to everyone who has contributed in various ways to this book. My sincere appreciation goes to my mother, my brothers and sisters, and every member of the Adejumo family who told me more about my father so as to make this book a very rich resource.

I also acknowledge all the authors that have written about Baba Sala. The biographical account by Akinola B., Oyedokun C., and Ajani K. (2017) in their book titled Triumph of Destiny was particularly detailed and highly useful.

I appreciate all my friends, especially the Omoluwabis of Ilesa Grammar School, 1989-1994 set. Thank you for believing in me. You inspire me every day.

Lastly, I appreciate my husband, Deola Ayibiowu for always encouraging me so that this book could be completed without delay. I thank my kids for their endurance, understanding and love.

God bless you all.

My deepest gratitude goes to God for giving me inspirations to write deep revelations which I did not read from any book.

I also wish to express my gratitude to everyone who has contributed in various ways to this book. My sincere appreciation goes to my mother, my brothers and sisters, and every member of the Adejumo family who told me more about my father so as to make

this book a very rich resource.

I also acknowledge all the authors that have written about Baba Sala. The biographical account by Akinola B., Oyedokun C., and Ajani K. (2017) in their book titled Triumph of Destiny was particularly detailed and highly useful.

I appreciate all my friends, especially the Omoluwabis of Ilesa Grammar School, 1989-1994 set. Thank you for believing in me. You inspire me every day.

Lastly, I appreciate my husband, Deola Ayibiowu for always encouraging me so that this book could be completed without delay. I thank my kids for their endurance, understanding and love.

God bless you all.

INTRODUCTION

OUR BLACK HEROES

How awesome it is to be one of the greatest and most influential people who ever lived! It means such a person left his footprints on the sands of time and his or her achievements are always remembered. Most accounts of the top influential people in history are dominated by European philosophers, politicians, scientists, businessmen and religious figures. You have read about Abraham Lincoln, the 16th President of the United States who issued Emancipation Proclamation 1862 to end slavery in the country, Charles Darwin, the famous British scientist who was the proponent of the theory of evolution. Christopher Columbus, Wold's great explorer who discovered America for European colonisation, Bill Gates, the founder of Microsoft, and Michael Jackson, the great American musician.

It should be remembered that colonialism involves economic exploitation as well as the superimposition of European culture and ways of knowing on African people to the displacement of African knowledge.

From time immemorial, Africans have also made remarkable

achievements in history. Many historical works have confirmed that Africa, especially Egypt had great scientists and philosophers who made contributions to World civilisation. For example, smallpox inoculation in Europe was learned from an African slave who had undergone a similar procedure in West Africa (Koo 2007). In architecture, the Egyptian Pyramids, the towering structures of Aksum and Great Zimbabwe were examples of African advanced architecture. Unfortunately, due to long years of European colonisation, the achievements of many African Heroes could not make it to any written history. It should be remembered that colonialism involves economic exploitation as well as the superimposition of European culture and ways of knowing on African people to the displacement of African knowledge.

You can neither become a hero by doing nothing nor become great by achievements that benefit you only. Greatness is achieved when your personal efforts lead to outstanding achievements with wide-reaching impacts. When you are always thinking of what you can do differently so as to create solutions that will alleviate societal challenges, you are on the path to stardom.

However, modern histories have been recognising black heroes, correcting the disparaging distortions of African peoples' histories and contributions to World's civilisation. Among the world's top influential people are Martin Luther King, American civil rights campaigner, Nelson Mandela, anti-apartheid activist and South African first Black President, and Barrack Obama, the first black man to become American President. Many African leaders became heroes for fighting for the independence of African countries from European colonisation. Examples include Obafemi Awolowo and Nnamdi Azikiwe of Nigeria, Kwame Nkrumah of Ghana, Julius Nyerere of Tanzania, Senghor of Senegal and Sekou Toure of Guinea.

A hero is a person who is admired for courage, outstanding

achievements, or noble qualities. Heroes are great men who ever lived. Heroes are celebrated because they dared to be different, took great risks to venture into areas many would not, and made great sacrifices in order to achieve goals for the benefit of their societies and humanity at large. In the real African sense, heroism and selfishness are not compatible. You can neither become a hero by doing nothing nor become great by achievements that benefit you only. Greatness is achieved when your personal efforts lead to outstanding achievements with wide-reaching impacts. When you are always thinking of what you can do differently so as to create solutions that will alleviate societal challenges, you are on the path to stardom.

Success is not about the type

of job you choose to do but about

how you choose to do it.

Greatness is not limited to the political sphere, every vocation offers opportunities for the courageous African youth to shine and become a hero. Nigeria has produced great heroes in the political arena, academics, entertainment industry and many more. Nnamdi Azikiwe, Obafemi Awolowo and Ahmadu Bello became heroes for their struggles for Nigerian independence. Fela Anikulapo Kuti was a renowned musician and the pioneer of Afrobeat, Chinua Achebe became great for his prolific writing and was nicknamed the father of modern African writing, Gani Fawehinmi was a civil rights lawyer and politician known for his belief in the principles of rule of law and protection of human rights.

Moses Olaiya Adejumo (Baba Sala) became known for his comedy theatres. He was Nigerian foremost comedian. Aliko Dangote is Africa's richest man and he is known for his successful businesses and his philanthropic activities. Mike Adenuga was the founder

of Globacom, the first private indigenous telecommunication in Nigeria. Kanu Nwankwo is a great international footballer, he is also known for his heart foundation that gave hope and restored good health to many children with the deformed heart. Pastor Enoch Adeboye is a religious leader and the General Overseer of the Redeemed Christian Church of God which is the largest church in Nigeria.

Whether you choose to be a doctor or an artist, you can be great and be internationally recognised. Success is not about the type of job you choose to do but about how you choose to do it. Learning from the success principles that have helped the earlier African heroes can equip the younger generations with the knowledge necessary for great accomplishments. While the experiences of European heroes can be helpful, they may not be perfectly relevant to the African youth who lives in cultural and socio-political settings totally different from the West.

This book explores the historic life of one of Nigeria's greatest heroes, Baba Sala, with the aim of drawing inspiration for success from his experiences. Baba Sala's story will relate well to African youths and young entrepreneurs because the challenges faced by Baba Sala were not strange to many Nigerians. But while many people were abandoning their ambitions because of challenges, Baba Sala turned his stumbling blocks to stepping stones. Baba Sala is a story of resilience, disappointments, risks, and success. It is hoped that this book will make every African shun mediocrity while spurring everyone to aspire for greatness.

CHAPTER ONE

WHO IS BABA SALA?

Moses Olaiya Adejumo popularly known as Baba Sala was a veteran and ace comedian, dramatist, musician, film producer and actor. From the 1960s through the 1990s even to the early 2000s, Baba Sala was a household name in Nigeria because of his hilarious TV shows, films and comedy play. Baba Sala is regarded as the father of modern Nigerian comedians. Specifically, Baba Sala was the one who created the laughter business in Nigeria. In other words, Moses Olaiya was a creator, a pace-setter and an inventor. He ventured into comedy business not because there was any government funding or a conducive business environment or a ready large market to take advantage of. In fact, these necessary factors were absent. To actualise his passion and business ideas, Moses Olaiya had to train himself, raise capital by himself, develop strategies to survive an unpredictable business environment; and he had to create his own market or customer base. Baba Sala was thus a courageous adventurer and a risk taker.

Baba Sala was one reason Nigeria was not a sick nation despite underdeveloped health care system. Since health is wealth, and laughter contributes to health, Baba Sala had contributed to the wealth of Nigeria in the 1970s and the 1980s through the laughter-health channel.

Baba Sala was loved because he brought joy to many Nigerian homes through his comedy. Many scientific studies show that laughter and comedy can help with depression, anxiety and other mental illnesses. Laughter releases hormones linked with reducing stress, boosting immune response and strengthening social relationships. Scientists also show that laughter can increase confidence, self-esteem, creativity, positivity and resilience. These health benefits of laughter underscore the great contributions of Baba Sala's comedy to the country. His weekly TV shows gave Nigerians free weekly doses of health-boosting humour that must have saved a lot of people from spending money on anti-depression drugs despite a hard economy. Baba Sala was one reason Nigeria was not a sick nation despite underdeveloped health care system. Since health is wealth, and laughter contributes to health, Baba Sala had contributed to the wealth of Nigeria in the 1970s and the 1980s through the laughter-health channel.

Moses Olaiya professionalised comedy in Nigeria. Until Baba Sala went into the Nigeria entertainment scene, comedy was not a profession in Nigeria, Nigeria's entertainment industry had no significant contribution to Nigeria's GDP and the sector generated no significant government revenue. However, the determined efforts, resilience and sacrifices of Moses Olaiya Adejumo became the beginning of a positive turn for comedy in Nigeria and for the entertainment industry as a whole. Although Baba Sala went through many challenges, his efforts and the efforts of other founding fathers of entertainment was not futile. Over the years, the Nigerian movie industry has grown rapidly to the second largest film producer in the world. Moses Olaiya Adejumo was among those who created the solid foundations that made Nigeria's movie industry an exceptional global phenomenon today.

If Christopher Columbus became a world hero because of his ocean exploration and the discovery of the new world, arguably Baba Sala qualifies to be among the World's greatest heroes for

being the first Nigerian to venture into comedy profession and for bringing into foreshore an industry with great economic opportunities for the people and the government of Nigeria.

International Monetary Fund (IMF) reports (2016) affirmed that the movie industry has contributed more than 1.4 percent of the Nigerian Gross Domestic Product. Specifically, the Nigerian film industry employs more than 1 million people and generates more than US$7 billion for the national economy. Comedy, film acting and other entertainment works which were not regarded as any noble career, especially by Nigerian educated elites, have now become respected professions and a sector from where government generate tax revenue. The implication of this is that the comedy and film industry is a major source of employment and earning to Nigerian citizens and a large source of tax revenue for the Nigerian government. Moreover, as Nigerian films are being exported to other African countries and the rest of the world, the comedy sector has become a source of foreign exchange earnings in Nigeria.

These great economic developments became possible solely because in the 1960s, Baba Sala dedicated himself to exploring the unknown world of comedy. If Christopher Columbus became a world hero because of his ocean exploration and the discovery of the new world, arguably Baba Sala qualifies to be among the World's greatest heroes for being the first Nigerian to venture into comedy profession and for bringing into foreshore an industry with great economic opportunities for the people and the government of Nigeria.

Will you dare to be black and bold like Baba Sala? The subsequent chapters show how one can draw inspiration from the life of Baba Sala.

CHAPTER TWO

BORN LIKE YOU!

It is not uncommon to assume heroes are superhuman! Maybe they had extraordinary privileges that made their great accomplishments possible, maybe they were just created and destined for greatness. The fact, however, is that heroes are born the same way other people are born.

Every individual is born with many talents and nobody's existence is without challenges and odds. Heroes are not supernatural beings, they are ordinary people who chose to face their challenges with an extraordinary determination. Baba Sala is one of them. He had an ordinary background but lived an extraordinarily impactful life.

Every individual is born with many talents and nobody's existence is without challenges and odds. Heroes are not supernatural beings, they are ordinary people who chose

to face their challenges with an extraordinary determination.

Moses Olaiya was born on the 17th May 1937 at Ilesa to the family of Mr. Ebenezer Adejumo and Mrs. Celina Adejumo. He was the second child but the first male child of the parents. Doubtless, a male child is the pride of an African home. Nevertheless,

Moses did not have the privilege of growing with his own parents. His father and mother lived separately and the marriage was not without challenges. His dad lived and worked away from home in the Northern part of Nigeria. His mother died when Moses Olaiya was quite young. Consequently, Moses was raised by his grandmother and at different times of his growing up years, he had to live with relatives in different parts of the country. Moses was also a product of polygamy, as his father had other wives and children.

Thus, little Moses Olaiya had enough internal and external challenges to stop him from aspiring for greatness. His internal challenges were problems peculiar to his background which include the absence of a biological mother to love and cherish, inadequate fatherly care, hardship, abuse, and vulnerability. Although his grandmother was always ready to pamper him, Moses Olaiya's experience of living with some of the relatives was not always pleasant. Sometimes he would be recklessly abandoned and many times he would go without food especially when being punished. And often times. Put differently, Moses Olaiya did not have much of comfort living as a child.

The gift of greatness is not on you but in you. Long years of imprisonment did not destroy the hero inside Mandela, many years of racism did not destroy the hero inside Barrack Obama. It does not matter the difficult

situations you have been through over the years,

those hardships can change nothing about the

purpose of God for you.

The external challenges Moses Olaiya faced were the environmental problems prevalent during these periods. Moses Olaiya was born during the colonial era. At the Berlin Conference of 1884/1885, the European powers divided Africa among them-

selves for unobstructed exploitation in what is referred to as the scramble for Africa. From that time till 1960, Nigeria was under British colonial rule. European colonialism brought many changes to Nigerian political and socio-economic structures. Significantly, through colonisation, Europeans seize Africa's mineral and agricultural resources for European factories. African economies were also restructured so that only raw materials needed by industries in Europe are produced while African countries were made a consumer nation for European manufactured goods. Many people were also forced out of their livelihood to work in colonial exploitative companies at extremely low wages.

In Nigeria in particular, colonial policies exploited and monopolised Nigerian cash crops and other resources for the benefit of the United Kingdom (Njoku 1987). While these selfish colonial economic policies caused many Nigerians hardship and poverty, the beneficiaries were the European exporting companies and their African intermediaries (ibid). Moses Olaiya was born at a time the indigenous Africans were being disenfranchised and impoverished by colonial policies. Nevertheless, colonialism had other positive impacts on Nigeria such as the introduction of modern infrastructures: railways, motorable roads, and telegraph as well as the influx of missionaries who established elementary and secondary schools. But arguably, these positive developments could possibly be achieved without exploitation and subjugation of Africans by imperialism.

Moses had his early education in the midst of these internal and external challenges. He attended Methodist Primary School Oke Ese, Ilesha, and Saint Luke's Anglican School Jos. He proceeded to Obokun boy's High School, Ilesa where he completed his secondary school in 1958, two years before Nigeria's independence. Moses went to school amidst all odds; trekking long distances to school every day. With his polygamous father far away in Northern Nigeria, motherless Olaiya could not but be a poor student. However, despite these difficulties, it was acknowledged that Moses Olaiya was a humorous fellow, always cracking jokes and

creating fun and laughter out of everything and for everyone around him. Throughout his school days, entertaining people was Moses Olaiya's hobby.

Moses Olaiya's humorous personality despite hardship, abandonment and a colonial environment was an evidence that innate abilities and natural talents are usually unaffected and cannot be destroyed by poor family background and harsh socio-political environments. The gift of greatness is not on you but in you. Long years of imprisonment did not destroy the hero inside Mandela, many years of racism did not destroy the hero inside Barrack Obama. It does not matter the difficult situations you have been through over the years, those hardships can change nothing about the purpose of God for you. No harsh weather can change the quality of the treasures of greatness in you. Keep looking to discern your innermost abilities. The seed of greatness is inside of you and not hooked around your estranged family or unfavourable government policies. Today's celebrated heroes were born like you and faced challenges similar to yours. If they can be great despite all odds, surely you can!

CHAPTER THREE

DARE TO BE DIFFERENT

One unforgettable impact of colonisation is the superimposition of European culture, language, ethics and ways of knowing on the African people, making inferior and subjugating traditional knowledge and customs. During the time Baba Sala was growing up, it was very prestigious to acquire western colonial education. This is not to say that Africa did not have its indigenous system of education. Studies show that Nigerian pre-colonial societies had comprehensive and functional indigenous education that did not only teach intellectual and vocational skills but also morals and cultural norms. But the advent of western knowledge inferiorised indigenous activities.

Western Colonial education was associated with high paying modern and colonial jobs which also instigated migration from the rural area to cities and the abandonment of traditional economic activities such as farming and other traditional vocations. Moreover, some Nigerians who had acquired Western education got increasing opportunities to get involved in the colonial project and get famous and rich, especially towards independence. The challenge however is that formal education during this period was expensive with only few tertiary institutions in Nigeria. In fact, as at the time Moses Olaiya would be finishing secondary school, there were only two higher institutions in

Nigeria, namely Yaba Higher College and the University College Ibadan. Consequently, not many Nigerians could study beyond secondary school.

Moses Olaiya's father, Mr Ebenezer Adejumo was an accountant, and he desired that his first son would follow suit in pursuing a modern profession as against traditional vocations such as entertainment. Moses Olaiya's father wanted him to acquire more formal education so as to benefit from the opportunities the colonial modern system offered. But instead of Moses to make efforts to further his education or even pick up some clerical colonial work which were respected in the colonised society, Moses followed his passion by venturing into entertainment vocations.

Daring to do what nobody or what not many people have done is one of the attributes of great people. That nobody is doing it does not mean it cannot be successfully done. Not having any precedence should not make anyone afraid to try an endeavour. Daring to do what nobody has done is what makes anyone a pacesetter and an originator.

Moses Olaiya's entertainment adventure began with magic, which was an already established informal entertainment business during the period. Although some believed that magic was a profession for cheats and fraudsters, Moses went into magic mainly to express his entertainment skills and creative talents. Magic gave him opportunity to entertain a wide range of audience within and around his hometown, Ilesa. But most importantly, magic provided the entry point to a journey to self-discovery of his creative talents including music and comedy.

If anything, Moses Olaiya was not thinking of becoming an accountant, a lawyer or a doctor, against his father's wish. So, one of the greatest challenges for Moses was having a passion and ambition contrary to his father's desire as well as unacceptable to a colonised society. It should be noted that Mr EEbenezer Adejumo, Moses' father had two other sons, though younger than Moses and

they all studied to have good degrees, and took after their dad in taking up modern professional jobs. So Moses Olaiya was the odd one out in the family. Moses must have been very bold to choose a career not supported by his parent, and not regarded as important by his society–He was not afraid to be different.

Daring to do what nobody or what not many people have done is one of the attributes of great people. That nobody is doing it does not mean it cannot be successfully done. Not having any precedence should not make anyone afraid to try an endeavour. Daring to do what nobody has done is what makes anyone a pacesetter and an originator. The fear of rejection is one reason many innovative ideas were never expressed or implemented. Moses Olaiya's decision to pursue a career in entertainment is actually a challenge to the colonial mentality that formal sector job is necessary for success. It shows that despite having formal education to secondary school level, Moses Olaiya took pride in the African culture.

Even though the colonial economic policies did not take traditional entertainment as important, in the Yoruba precolonial societies, entertainment was an important sector of the economy. The sector comprises of wide range of actors including praise singers, drummers, dancers, storytellers, poets, jesters, carvers and sculptors and these were all recognised and respected for their indelible contributions to a happy society. The various art of entertainment including drumming, dancing, carving are important parts of the cultural heritage of the Yoruba. In fact, some Yoruba families with long histories of playing drums include 'ayan' as part of their name to display the African pride in drumming as a noble profession.

However, colonialism and western civilisation led to the reorientation of many Nigerian societies from traditional economic activities such as farming, drumming, and singing to high paying non-rigorous clerical jobs. Westernisation and formal education have caused a lot of educated elites to dislike non-white collar

jobs which have contributed to the present high level of poverty and hunger in Nigeria. Due to modernisation and westernisation, traditional entertainers are regarded as beggars. If Moses Olaiya had followed this colonial trend, he would have pursued a career in the formal sector. But he followed his passion and chose to be different. He chose not to mind the embarrassment of choosing a career classified for beggars, at the end, he became great. If your passion is different, be bold to be different, damning the consequences. Your bold unique steps lead to stardom. Dare to be different?

CHAPTER FOUR

THE GOD FACTOR

That you follow your passion does not guarantee a problem-free career life. Getting into trouble on a few occasions is inevitable in the journey of life. In fact, the very first steps you take towards fulfilling your potentials may lead to problems that will make you reconsider your decisions. This was the experience of Moses Olaiya. After leaving secondary school, instead of pursuing a modern job, he chose to follow his passion, which was to entertain people with his creative energy and perform before an audience. Magic was the thriving business around him where he believed his skills could be put to maximum use to achieve his desired objective. Moses Olaiya was doing well in magic practice and was even going on tours with his group to villages and towns around Ilesa. `It is important to mention that one of Nigeria's most famous magicians, Professor Pella was a contemporary of Moses Olaiya and they had several magic performances together.

However, before Moses Olaiya could make notable advancement in magic, he got into some unexpected trouble and was declared wanted by the Police. It happened that without Moses Olaiya's knowledge, some members of his team in the magic practice had duped an Ipetu-Ijesha chief by promising to help him double his money. After realising that the money doubling magic was a

scam, the chief reported the incidence to the police who hunted for Moses Olaiya, the team leader. The police traced Moses Olaiya to his grandmother's house where he was arrested and later charged to court (Akinola et al 2017). The police arrest was indeed a big embarrassment for Moses Olaiya who had never been involved in shady deals. He was also afraid he could go to jail. Going to prison for a criminal offence would tarnish the family name and could put an end to all his dreams, yet the chances of Moses Olaiya winning the court case were very slim.

the best business idea is not insulated against storms and difficulties. But the African mind will not give up because of the belief in the spiritual and in the existence of God. This is one reason suicide rates in Africa is far less than those of Western nations. We have hope that when all physical hope is lost over a particular case, there could still be a spiritual intervention that can bring the desired change.

This was one of Moses Olaiya's most dreadful moments. With nobody to turn to, he was forced to move closer to God and to pray. It was during this period that a relative invited Moses Olaiya to Cherubim and Seraphim Church, Idasa, Ilesa. He sought the prayers of members of the church over the court case. At the church, Moses was asked to go to the church's 'Mercy Arena' to pray to God and make a vow. He cried helplessly and prayed vehemently vowing to God that if God would miraculously deliver him from the court case, he would serve Him all his life. Amazingly, his prayer was answered. The court suddenly declared him discharged and acquitted of the offence. The dreadful experience and God's miraculous intervention marked the turning point in Moses' life because he lived the rest of his life and pursued his career with the fear of God.

He was also a devoted member of the Cherubim and Seraphim

Church till his death. But that experience made Moses abandon the practice of magic and relocated from Ilesa to Lagos.

Moses Olaiya's awful experience offered a lot of lesson for the African youths. There will be moments in our lives when the sky would be dark as if the sun would not shine again. Moreover, the best business idea is not insulated against storms and difficulties. But the African mind will not give up because of the belief in the spiritual and in the existence of God. This is one reason suicide rates in Africa is far less than those of Western nations. We have hope that when all physical hope is lost over a particular case, there could still be a spiritual intervention that can bring the desired change. The belief in God also means the African youth can never be stranded or helpless. Even when there is nobody to turn to, we have a consciousness that there is a God in heaven to cry to.

"Talent and passion are not enough to achieve greatness. Life can sometimes bring challenges which your education, skills, connections and wealth would not be able to help. We all need the God-factor".

Moses Olaiya's experience the spiritual component of life is as real as the material aspect and that God answers prayers.

Another lesson from Moses Olaiya's experience is that often times, the terrible unexplainable challenges we face are not meant to mar us but to make us become who God wants us to be. Many of us will never turn to God or live to please him until we have experienced serious troubles. So it seems God permits those challenges to get our attention and to make us align to his will. Did you find yourself in some trouble in the process of actualising your dreams? Never think that would be the end! The earlier you begin to seek God, the faster you will get out of your troubles.

Another lesson from Moses Olaiya's experience is that: "Talent and passion are not enough to achieve greatness. Life can sometimes bring challenges which your education, skills, connections and wealth would not be able to help. We all need the God-factor". Challenges allow you to have sober reflections that will help you refine your goals. As Moses Olaiya relocated from Ilesa to Lagos, and as he explored other aspects of his creative talents, he was ever conscious of the God-factor. The consciousness of the God-factor brings a reassurance and hope that there will always be a light no matter the darkness. The God-factor also implants caution in the African mind to live a God-fearing and morally upright life.

CHAPTER FIVE

EVERYTHING TO SURVIVE

Moses Olaiya relocated to Lagos in 1959. Moving to Lagos was the beginning of a new life for him. He had put the practice of magic which had been his main source of livelihood behind him. Lagos was the hub of business and political activities in Nigeria and offered many opportunities for any educated young man. Lagos life was also very expensive, compared to Ilesa, and it would be very difficult for him to survive in this city without a steady source of income. Therefore, it was time for him to reconsider his parent's advice, picking up a job. He got his first job at Empire Hotel, Yabba where he worked as a driver. Specifically, he was driving an orchestra group. Travelling around with a group of musicians must have ignited his creative spirit and further revived the entertainer in him.

That the job you are offered to do is not what you are passionate about is no excuse not to do it well. Those who want to be great are diligent in all things.

But Moses Olaiya's father preferred that his first son worked with the government. Consequently in 1960, at the age of twenty-five, he joined the Lagos Town Council as a sanitary inspector

and he worked there for eight years. His trouble with the police at Ilesa was evidence that his father was right in insisting on securing a stable job. Besides, during the pre-independence and post-independence era, working with government offered many opportunities including stable income, prestige and job security. Interestingly, he also took up other jobs so as to have multiple sources of income. After closing work as a sanitary inspector, Moses Olaiya worked as a thrift collector, going around his neighbourhood to collect customers' daily contributions or savings. In the early evening, Moses Olaiya would work as a remedial coaching teacher giving instructions to students and in the night he would work in the hotel as an attendant.

This routine only proved that Moses Olaiya was never a slothful person. One of the attributes that made highly successful individuals great is hard work. Successful people are usually hard working people. They are not only hardworking at businesses related to their passion, but they are never slothful in all businesses. That the job you are offered to do is not what you are passionate about is no excuse not to do it well.

When your dreams are not working despite hard work and commitment, it may be wise to retreat so as to restrategise.

Those who want to be great are diligent in all things. The fact that Moses Olaiya engrossed himself with businesses unrelated to his passion did not mean that he for once, forgot about his passion. Diverting his energy into other impactful activities seemed to be his way of retreating after a failed attempt in magic entertainment. When your dreams are not working despite hard work and commitment, it may be wise to retreat so as to restrategise. Moses Olaiya was also doing everything to survive so that he could be well positioned to successfully launch out his dreams. A steady income further increases your ability to take risks. Successful launching of any dream business requires that one gets

resources and time to determine the direction, to conquer inner fears, to fine-tune the ideas and to also make a mental commitment to the vision. Sometimes the road to your passion starts with doing things you are not passionate about.

Fine-tuning your ideas requires that you nurture and develop your talents. Getting the right type of education or learning is a necessary step to having a better you. Moses Olaiya would not go back into entertainment until he had gotten some degree of formal training. Consequently, he enrolled himself in the Adult Drama School, organised by Mr. Christopher Olude of the Adult education department of the Ministry of Education in Lagos. He also took lessons on the rudiments of music, taught by a Ghanaian music instructor, Mr. Samuel Kwashie (Akinola et al 2017).

Getting the right type of education or learning is a necessary step to having a better you.

To have a practical experience of what he had learnt in school, he apprenticed himself with one of the leading musical bands in Lagos, the Tunji Lucky Faces Orchestra, and there he learnt how to play the guitar and other musical instruments. Moses Olaiya was with the Tunji Lucky Faces Orchestral group for three years.

Kicking off the journey of your dream career with an apprenticeship is one of the best ways to launch out. An apprenticeship will enable you to get first-hand knowledge of how the industry works. Your experience during the apprenticeship period will further enable you to decide if that is what you really want. Apprenticeships also allow you to work and earn some reasonable level of income, learning the key skills needed for you to be successful in your chosen career. And most importantly, apprenticeship allows you to put into practice both your natural talents and the new skills you learnt in school into practice and you have more experienced professionals on hand to answer your questions and to guide you on how things are done to achieve the best results. Taking on various responsibilities and trying new things

during the period of your apprenticeship help you get better and at the end, you are more confident to work independently.

After three years of apprenticeship, Moses Olaiya started his own juju musical group called the Federation of Rhythm Dandies. He led the band and played the guitar. The orchestral group usually entertained guests with soul-lifting tunes and beautiful compositions inside and outside the hotel where he worked. The group largely played highlife music, which was the predominant music genre at that time. Due to the consistently excellent performance of the Moses Olaiya led Federation of Rhythm Dandies, in no time; the band became a popular orchestral group in Lagos. Apart from entertaining a wide range of audiences, one of the greatest achievements of Moses Olaiya while doing music was his discovery and mentoring of Sunday Adeniyi Adegeye who later became popularly known as King Sunny Ade.

Sunday Adeniyi joined the Federation of Rhythm Dandies as a drummer. But Moses Olaiya taught him how to play the guitar. Discovering Sunday Adeniyi's outstanding talents on the string instrument, Moses Olaiya personally tutored and mentored him in playing the instruments. Moses Olaiya also encouraged Sunday Adeniyi to start his own musical band after two years of learning. Moses Olaiya connected Sunday Adeniyi with the man who supplied his first set of musical instruments. He also told Sunday Adeniyi that if after nine months the musical band was not doing well, Sunday should return to the Federation of Rhythm Dandies.

Successful people are not afraid to help others to achieve success, because they know that the success space is unlimited. Another's success can neither reduce your own success nor decrease your opportunity for greatness.

But since Sunday Adeniyi launched out, he never had any reason to look back. Instead, he was in the frontline of the development and promotion of juju music internationally. The Juju music is a

type of music that combines traditional Yoruba vocal forms and percussion with Western rock and roll. He later became Nigeria's music icon popularly known as King Sunny Ade.

That Moses Olaiya discovered Sunday Adeniyi's musical talents and decided to nurture and promote the talents is also a heroic action. Successful people are not afraid to help others to achieve success, because they know that the success space is unlimited. Another's success can neither reduce your own success nor decrease your opportunity for greatness. An African adage says "The sky is wide enough for all birds to fly without clashing". In fact, contributing to another's success can actually expand your success because that person's success story would never be complete without your name being mentioned. Thus, the spread of the success story of that person you helped automatically promotes your glory. King Sunny Ade is an international music star and an African legend whose success story always brings back to memory the work of Moses Olaiya Adejumo. One sure way to immortalise your name is to help others to achieve success. In contrast being stingy about what you know is another sure way to quickly go into extinction. According to Brian Tracy "Successful people are always looking for opportunities to help others. Unsuccessful people are always asking, 'What's in it for me?'

During the 1960s, Moses Olaiya led Federation of Rhythm Dandies was, however, competing with several other popular orchestral groups including those led by I.K Dairo, Eddy Okonta, Bobby Benson and others. To stand out in the crowd, Moses Olaiya added a creative touch to his highlife music by including violin in his orchestra, giving his music an unusual emotional feel. That singular step differentiated Moses Olaiya's music from the existing ones and helped him to have a niche in the Lagos music market. Product differentiation is an important business strategy, to survive is a highly competitive market. Often times, your passion may only produce ideas and products already existing in the marketplace.

One sure way to immortalise your name is to help others to achieve success. In contrast being stingy about what you know is another sure way to quickly go into extinction.

By definition, products differentiation is a marketing strategy that businesses use to distinguish a product from similar products available in the market and to convince the customers that the product is positively different from all other similar products available. Your successful products differentiation strategy creates brand loyalty among customers.

But beyond product differentiation, Moses Olaiya also adopted a business diversification strategy. Business diversification is but not putting all your eggs in one basket. Offering only a single line of product is one reason a business can die quickly because it limits the number of customers such business can attract. Diversification is a tried and trusted business survival and growth strategy. It involves taking new risks, venturing into new markets and creating new services or products. If anything, new products and services will enable your business to make more sales to existing and new customers and also expand your business into markets that would otherwise have been closed to you. Because Moses Olaiya wanted his entertainment business to expand beyond the music market, he diversified into the world of drama. He knew he was not just a musician but a multitalented entertainer, so diversification allowed him to explore his other creative talents, especially his acting drive.

Moses Olaiya had earlier attended a drama school. So it was time to praticalise and turn into business what he had learnt in school. In 1965, at the age of twenty eight years, Moses Olaiya founded a theatre group he called Moses Olaiya Concert Party. The group mainly performed serious dramas and historical plays.

Product differentiation is an important business strategy, to survive is a highly competitive market. Often times, your passion may only produce ideas and products already existing in the marketplace.

The essence of true education is not just to generate knowledge but to activate one's consciousness to take welfare-improving actions. Unfortunately, many youths acquire education with the purpose of finding good jobs after graduation and whenever they cannot get the anticipated kind of job, they remain idle.

The essence of true education is not just to generate knowledge but to activate one's consciousness to take welfare-improving actions.

Inability to translate knowledge into life-improving action is one reason many educated people are unproductive and poor. Any knowledge that cannot improve your condition is miseducation and ignorance. An emancipatory education is that which empowers African youth to take action that will improve his own condition and the condition of his society. Moses Olaiya displayed his ability to translate his acquired knowledge into action.

It is worth mentioning that before Moses Olaiya ventured into acting, there existed several well established dramatists in Nigeria such as Herbert Ogunde, Duro Ladipo, and Kola Ogunmola. Despite the existence of these trailblazers, Moses Olaiya boldly launched his own drama group, believing in himself and his capacity to excel amidst keen competition. But it was very difficult for the Moses Olaiya Concert Party to stand out in the drama in-

dustry or even beat its competitors. This is because the thematic focus and presentation of his dramas and plays were very similar to the dramas and plays performed by existing theatre groups. Being a man who believed in product differentiation, Moses Olaiya's next innovative mission was to find how to differentiate his theatre from existing dramas so he could carve a niche for himself in the theatre industry.

Having observed that all theatre groups mainly performed serious and tragic dramas, Moses Olaiya believed that the way to stand out is to invent more relaxing entertainment. This was what led to the birth of comedy-drama in Nigeria. He therefore took a turn from plays that made the audience cry to dramas that amuse the audience. That is a great innovation and an unprecedented invention that made him an outstanding megastar, an African hero, a success and an achiever.

Inability to translate knowledge into life-improving action is one reason many educated people are unproductive and poor. Any knowledge that cannot improve your condition is miseducation and ignorance.

Moses Olaiya had all the attributes common to highly successful people. According to Brian Tracy, "Successful people are ambitious, courageous, committed, always prepared and ever learning". Accordingly, successful people achieve greatness because they do not see themselves as inferior to other people. They are never afraid to take another bold step. They are never intimidated by existing players in the area of their interest. Rather, they join the players but with the aim of doing things differently and better. Even though trailblazers already existed in Nigeria music and drama industry, Moses Olaiya was not afraid to explore and express the entertainer in him through this industry. Successful people always boldly confront the fears that hold most people

back. Facing your fear, doing what you are afraid of is the way to kill fear and achieve success. High achievers are also committed to pursuing their dreams.

Highly successful people also achieve extraordinary results because they are always prepared to make the kind of sacrifices the average person is not willing to make.

Moses Olaiya was committed to actualising his dream. The lack of government or family support was not an excuse for him to drop his vision of becoming a successful icon. Rather, he took several odd jobs in order to raise sufficient funds to finance his dreams.

Highly successful people also achieve extraordinary results because they are always prepared to make the kind of sacrifices the average person is not willing to make. Therefore, Moses Olaiya was willing to spend the earnings from his full time government employment and other jobs to sponsor his vision even when those endeavours were bringing no returns. In many African societies, there are no adequate funding to sponsor new talents and innovations.

Your dream involves risks which you must be the first person to take. If you are afraid to invest in your dreams, who would take the risk?

Consequently, many great achievers from Africa are self-made heroes. You have to believe in yourself and be ever ready to selflessly invest in your dreams. Your dream involves risks which you must be the first person to take. If you are afraid to invest in your dreams, who would take the risk?

Every talent will remain in its crude form if it is not exposed to professional training. Acquiring technical skills in addition to your natural talents can make you exceptional in the quality of your knowledge and output. Education sharpens your talent and produces a higher version of your skills and abilities.

All high achievers are ever learning, so it was not surprising to see Moses Olaiya investing in both formal and informal education to develop his talent. Every talent will remain in its crude form if it is not exposed to professional training. Acquiring technical skills in addition to your natural talents can make you exceptional in the quality of your knowledge and output.

Every time there is still an allowance for

 improvement and an opportunity for expansion,

 then, that level of achievement cannot be the

final level of success you can achieve.

Education sharpens your talent and produces a higher version of your skills and abilities. It is clear that Moses Olaiya was ever trying to find the best version of the entertainer inside of him. That was why he went all out to acquire more knowledge and skills in that line. That is also the reason why he moved from magic to high life music and from music to tragic drama and from tragic drama to comedy.

Every time there is still an allowance for improvement and an opportunity for expansion, then, that level of achievement cannot be the final level of success you can achieve. Your greatness and achievement stop at that point where you stopped aspiring for

Oyindamola Adejumo-Ayibiowu

more.

CHAPTER SIX

ONCE IN A LIFETIME OPPORTUNITY

Success is a product of preparedness and opportunity. Life will always present everyone an opportunity to succeed, but the ability to make use of that opportunity to achieve success depends on the level of preparedness. When discussing success, opportunity can be defined as a situation or condition conducive for the maximum utilisation of your potentials and favourable to the attainment of your goal. It does mean a great opportunity is useless to someone who has not discovered his or her potentials or has not learnt how to fully maximise it. Opportunity is an external condition which, although you greatly desire its regular occurrence, you do not have control over its time of occurrence. However, you are in control of your preparations. You have the power to develop your skills.

The level of strength of your abilities and skills will determine whether or not you will be able to take advantage of an opportunity whenever it shows up. You may pray for opportunities, but hard work is what is required to get prepared. The best way to get ready for opportunities is to sharpen your skills and let them be in their best version.

You may pray for opportunities, but hard work is what is required

to get prepared. The best way to get ready for opportunities is to sharpen your skills and let them be in their best version. When a prepared man gets an opportunity, he becomes a success and a high-flier. But every opportunity given to an unprepared man will end in failure and disappointment.

When a prepared man gets an opportunity, he becomes a success and a high-flier. But every opportunity given to an unprepared man will end in failure and disappointment. Preparation, however hard, is the progressive journey to success. A man not working hard to perfect his skills is sitting in failure. Moses Olaiya's life further exemplifies these facts.

After his decision to change from serious drama to comedy, Moses Olaiya changed the name of his theatre group from Moses Olaiya Concert Party to Alawada Group. 'Alawada' is a Yoruba word for a joker or a clown or a funny fellow. Thus, by using a business name depicting humour, Moses Olaiya had differentiated his brand from other theatre brands and has also set out as a pioneer comedy producer in Nigeria. The right choice of the name of a product and brand is important for effective promotion. According to Carter McNamara, "The brand and product name should convey the nature of the service and the concise description of the product and how unique it is". The product name and brand should also make sense locally as well as understandable, if the business expands elsewhere. Although Moses Olaiya never attended a business school, he was able to choose a product and brand name that is concise and yet perfectly describing the business goal, which was to make people laugh. Choosing a Yoruba name also means Moses Olaiya appreciated the Yoruba culture and the Yoruba language and he also understood the impact of these traditional instruments in capturing local market.

That you speak English language does not

guarantee that you will have full knowledge of

English culture if you do not live in England.

The content of Moses Olaiya's comedy was also strategically focused around a character which he named 'Baba Sala'. The Baba Sala character was a cunning, lazy, illiterate and very funny old man. Baba Sala had a wife, Iya Sala, who was the sole breadwinner for the family. The couple had a daughter called Salamatu or Sala for short. Baba Sala usually wore funny but unique costumes which were usually extraordinarily large in size.

In Nigeria, traveling abroad has always been
fanciful and it is regarded as a great achievement.
This is mis-definition of success caused
by colonialism.

He was known for his extra-large clown eye glasses, extra-large bow tie made with a wooden board and Baba Sala's wristwatch was a big size table clock. The sight of Baba Sala would throw the saddest person into laughter. Although the Alawada's dramas actually addressed pertinent issues in the family and in the society, these were presented in the most comical way.

Baba Sala's rib-cracking dramas were highly ingenious and evidence that Moses Olaiya was highly talented. Nevertheless, the lazy and cunny character of Baba Sala and the amusing way he used to address serious social issues reminds one of the tortoise character in most African folktales. In Yoruba folktales, tortoise is usually a symbolic trickster with humorous, wise and sometimes, foolish behaviours which listeners can learn from. The tortoise is a character who survives as a result of his innate intelligence but it is also a character that falls victim to his own ploys. But in all, the tortoise stories are humorously didactic, and these

stories are eagerly listened to by everyone. There are many similarities between the tortoise character in African folktales and the Baba Sala character in Alawada comedies. It does show that Moses Olaiya drew much inspiration from his rich African cultural background. Folktales are integral part of African culture and they are valuable means of communicating African customs, norms and traditions verbally.

Interacting with other countries could expand one's knowledge of the world but the colonial mentality is one reason seeing London, Paris or any European city, would be placed above an opportunity to make lifetime local impact.

Just like Moses Olaiya was able to get inspiration for creative ideas from African culture, African youths have a lot to learn from African culture and tradition. Culture is the way of life of a people. Culture and tradition is enduring and it gives people their unique identities and relevance. African traditional ways of life include indigenous languages, myths, folksongs, cultural dance and traditional foods, traditional outfits and more. All these provide large resources from which the African youth can draw ideas for success. Unfortunately, due to European colonisation and westernisation, African culture and traditions are regarded as inferior and are disregarded by many people. There is nothing wrong in drawing inspirations from Western culture, Chinese culture or any other cultures. But the African youth must also believe that African culture is as rich and beneficial as any other. Moreover, African culture is most accessible to African youths compared to other cultures which are far away. That you speak English language does not guarantee that you will have full knowledge of English culture if you do not live in England.

The preference for inspiration rooted in Western culture is one reason African youths are in the drought of great ideas. Because

Moses Olaiya's inspiration comes from his culture and from his environment, he was never short of new comedies to satisfy his audience. And not long after then, an opportunity of a lifetime knocked on the door of musicians and dramatists in Nigeria through a talent hunt competition, organised by the Lufthansa Airline and another German-owned company. Moses Olaiya was more than ready for the competition. His theatre group participated and they presented a rib-cracking comedy titled 'Wackie and Die'. The performance of the Alawada group was outstanding because the comedy was a departure from the normal serious plays presented by other contestants. They captivated both the audience and judges with the comedy innovation, and the play was adjudged by all as original. The cultural feature of the innovation also made it relevant and easily acceptable. Moses Olaiya Adejumo and his Alawada group came first in the competition.

But for his prize, Moses Olaiya had to make a hard choice because he was offered the choice of going abroad to perform at a pageant or performing weekly on the Western Nigeria Television, WNTV for a year. He considered the options... It would be thrilling to visit the white man's country and to perform before a Western audience. But this is a one-off opportunity whose effect may never be long-lasting. However, performing weekly on the WNTV would introduce Baba Sala to all television viewers in all the wider range of audience and for a longer period of time. Moses Olaiya was wise to choose the weekly slot on WNTV.

The more you can spread out the wings of

your influence, the more successful you will be.

In Nigeria, traveling abroad has always been fanciful and it is regarded as a great achievement. This is mis-definition of success caused by colonialism. European Colonisation successfully projected European superiority and reoriented Africans to under-

mine their own culture and even see themselves as the inferior subject of the whites. This is the reason why visiting or living abroad as well as speaking the English language in Nigeria is associated with intelligence, prestige, and while local which were which embody the culture, moral and local knowledge are relegated and no longer spoken among some elites. Interacting with other countries could expand one's knowledge of the world but the colonial mentality is one reason seeing London, Paris or any European city, would be placed above an opportunity to make lifetime local impact.

Even after preparation, the ability to make right the choice when faced with many tempting options of opportunities is key to achieving the. A good understanding of the meaning of success will definitely enhance one's ability to make such right choices. True success is achieved when one attains results which have far reaching impacts. Many highly successful people have defined success that way: Living your passion, giving back and making impacts. Living your passion in such a way as to make positive impacts on your society is one sure way to become successful. The pursuit of self-interest goals such as making quick money and travelling abroad for pleasure may be very motivating, but it leaves people unfulfilled and empty. Success is contentment and fulfilment, and those feelings come after impacting lives, helping others or making someone else's life better.

The more you can spread out the wings of your influence, the more successful you will be. Baba Sala's weekly comedy shows on the WNTV expanded Moses Olaiya's audience from the fans he had in Lagos to all the people in the Western region of the country. The weekly programme had great social impact and also offered its audience free weekly dose of eyeglasses laughs. Due to its high impacts, the Alawada theatre was on the WNTV, for 10 consecutive years, instead of 52 weeks. The performances were not just humorous but always captivating. Because of these shows, it was not uncommon to see the streets of Ibadan and other places deserted at 7:00 p.m. every Wednesday night. In

small towns and villages where televisions were not common, those who had TVs had often brought them out into the open so that everyone in their how unique could gather round and watch. As Baba Sala continued to make the nation happy, he became very popular, very well-known brand and a household name.

In order to reach the non-Yoruba speakers in the nation, Baba Sala added a "pidgin English" comedy show called "My Pikin Friday". Apart from the weekly TV shows, Moses Olaiya also embarked on travelling theatre. The Alawada theatre group extensively toured Nigeria as well as other countries in West Africa for live comedy performances. Baba Sala's hard work and fame were rewarded with prosperity. He built and operated a hotel in Ibadan known as Awada Spot. He also invested in real estate in Lagos, Ibadan and Ilesha, his hometown. As a result of Baba Sala's great popularity, the former premier of Western State and great Yoruba leader, Chief Obafemi Awolowo, paid an unscheduled visit to Moses Olaiya's residence at Yemetu, Ibadan. The Premier out of curiosity wanted to meet the man playing the Baba Sala's character. The premier was amazed to find that the old Baba Sala he watched every week was a young man. Afterward, Moses Olaiya became the premier's friend and the official entertainer of the Western State Government. There is no profession that cannot make one great. Whatever you do, just do it well.

CHAPTER SEVEN

THE GIANT STRIDE

It is only in fables you will find young conquerors live happily ever after. In real life, no singular victory can guarantee an everlasting peace. Rather, each success achieved only prepares you for another round of challenges. Heroes are celebrated because they are always willing to take new and higher risks as they are ready to face higher challenges. Baba Sala was a hero because he would never rest on his oars. Even though he had the most watched TV show in the country and he had performed his stage plays across West Africa, Baba Sala's desire was to take his entertainment innovations into an international standard.

Taking giant strides in life often involves taking giant risks. Those who are too conservative to take big risks can never become champions.
Champions are risk takers.

In the developed countries of the world, entertainment, especially acting had moved beyond stage plays and TV shows to movies. Movies have a lot of advantages but it requires a huge

capital compared to TV plays. Baba Sala had mostly financed his ideas with personal funds. That was one of the reasons why he did many jobs at the onset of his entertainment career. But the amount of money needed to make a film was far bigger than whatever he has saved. Funding his dream, therefore, requires borrowing, which was a risk far greater than any risk he had ever taken. Taking giant strides in life often involves taking giant risks. Those who are too conservative to take big risks can never become champions. Champions are risk takers.

Baba Sala was ready to face the challenge. He was ready to take a bank loan and be the producer of the first comedy film in Nigeria. Out of his numerous comedies, he chose 'Orun Mooru'. Orun Mooru was worth the huge investment because it was a play which had been performed as stage plays and on TV, and whenever it was performed, it received audience acceptability and patronage. Orun Mooru was a successful project at low investment level, so there is a high probability that it would be successful at a higher level of investment. This shows that Baba Sala was not a careless risk taker. It is good to take risks but it is even better to take calculated risks. Many youths fail because they jump processes. It is always better to start small, to test your ideas with small investments and watch the progress before injecting large investment into it.

> It is always better to start small, to test your ideas with small investments and watch the progress before injecting large investment into it.

One of the major challenges Moses Olaiya faced in producing his first film was oppositions from envious colleagues. Baba Sala's great popularity and unusually high level of patronage made some other theatre practitioners jealous and they considered

him a threat in the industry. The fear of these competitors was that if Moses Olaiya produced 'Orun Mooru' as film, other films in the market would lose patronage. Consequently, these competitors began to do everything they could to stop Baba Sala's dream of producing a comedy film. They blackmailed him to put the production of 'Orun Mooru' on hold for two years. They also prevented him from gaining access to funds from Nigeria Film Corporation, an institution that had assisted other filmmakers in the country. They also threatened that no member of the theatre association would be allowed to work with him during the production of the film.

Your glory will always attract both lovers and haters. What is a strength to you is someone else's threat. It does mean that what you need to maximise to be successful is what some others believe they had to minimise to survive. It is about the survival of the fittest, but no opposition can stop you if you are determined to win.

Not deterred by his opponents' actions, he resolved to borrow money from a bank, using his personal properties as collateral. He also used non-aligned actors cast and crew members for the film. To achieve a masterpiece, Baba Sala used both indigenous and foreign film experts who shot the film with the best equipment available in the industry. It took about three months to shoot Orun Mooru. The film which was mastered in the United Kingdom became ready for public viewing in 1982.

To show their resistance and displeasure to the success of the film, Moses Olaiya's theatre opponents prevented the film from being premiered at the National Theatre, Iganmu Lagos, which was the best venue for the launch of such a masterpiece. But rather than give up, Moses Olaiya resolved to use Glover Hall, Marina, Lagos, to premiere the film but to make the hall suitable for the purpose, he had to invest in the renovation of the hall.

But despite all the odds and opposition, 'Orun Mooru' was a huge

success. It was recorded that Nigerians trooped to film houses in their thousands to see the first comedy film Nigeria would ever produce. In fact, the film was being shown simultaneously in all Nigerian cinema halls all over the country, while some cinemas showed Orun Mooru three times a day during the weekend. The production of 'Orun Mooru' was indeed, the giant stride that made Moses Olaiya a monumental success. Surely, it was a risk worth taking because the return on investment was great.

Success will not be achieved because everyone and everything cooperate to support your vision. Instead, you will achieve success when you have determined to achieve your purpose with or without the support of everyone, and in spite of everything.

Baba Sala's experience with 'Orun Mooru' offers great lessons for the African youth. Fulfilling your purpose cannot be without opposition. Your glory will always attract both lovers and haters. What is a strength to you is someone else's threat. It does mean that what you need to maximise to be successful is what some others believe they had to minimise to survive. It is about the survival of the fittest, but no opposition can stop you if you are determined to win. Success will be achieved when you do not give in to the darts of discouragement thrown at you by your opponents. Success will not be achieved because everyone and everything cooperate to support your vision. Instead, you will achieve success when you have determined to achieve your purpose with or without the support of everyone, and in spite of everything. Oppositions are in fact the evidence that there is a big glory ahead.

CHAPTER EIGHT

THE BIG FALL

The film 'Orun mooru' took Moses Olaiya to the peak of his career. Unfortunately, the film also became the bane of it. It should be noted that the Alawa group had expanded beyond a mere theatre outfit. The group had expanded to include hotels, music production, magazine production, recording, publishing and sales company. There is no doubt Moses Olaiya needed extra hands to manage these businesses. But it seemed the structure of Alawada Group was not good enough to manage a great success like 'Orun mooru'. Gross mismanagement of funds, indiscipline, sharp practices, unauthorised use of company's properties and poor record-keeping were the order of the day at Alawada group.

The enemies to dread are not those who openly declare war against you because they have actually given you notice to prepare. The real enemies to fear are those who appear as friends and laugh with you, because they have plenty of access to your unguarded hours.

The reason why it was difficult for Moses Olaiya to fully coord-

inate Alawada group was the composition of the staff as he had a large polygamous family and most of the staff of Alawada group were his wives, his wives relatives, his friends and members of his extended family. The reason for Moses Olaiya's large family was understandable. At the time he went into entertainment, comedy and drama was not regarded as a noble vocation by many Nigerians, especially the elites. Female artists were often regarded as flirts and were castigated. Consequently, one great challenge theatre groups faced was getting staff. The way out for early entertainers like Moses Olaiya was to have many wives. This was the reason why the Alawada Group was largely made up of family members.

But knowing well that among members of your beloved family are enemies aiming to pull you down, you must always be on guard when dealing with your friends, the same way you would have taken serious precautions when surrounded by enemies.

It appeared Moses Olaiya felt safe that his business managers were relatives. Thus, he let down his guards. There are however many challenges associated with running a business where the staff are relatives. It is usually difficult to separate the family from the business. Ego, rivalries and nepotism are also common challenges in family businesses especially when commercial successes are involved. These were true of Alawada group, where many staff (especially those who were senior members of the family) became uncontrollable. It was also difficult to seriously discipline erring staff due to the family ties. Some of the staff went as far as printing and selling their own tickets, diverting income that was supposed to go to the company into their private pockets. It was in the midst of this confusion that 'Orun Mooru' got stolen and pirated into VHS.

The piracy of 'Orun Mooru' was shocking news that could have

sent Moses Olaiya to an early grave. With the pirated copies of 'Orun Mooru' on the streets, only a few people needed to come to the cinema to see the movie, it became clear that Baba Sala would not be able to repay the huge bank loan he took to finance Orun mooru. Every effort to stop the piracy failed, and Moses Olaiya had to accept his new reality of indebtedness and helplessness. He was so frustrated that he considered suicide, but his hope in God kept him. To pay back his huge bank loan, Moses Olaiya had to liquidate some of his assets. The bank actually sold off some of his houses.

There are lots of lessons to learn from Baba Sala's bitter experience with Orun Mooru. It could be seen that Baba Sala had two sets of enemies, namely: internal enemies and external enemies. The external enemies were his envious colleagues in the entertainment industry, who saw his progress as a threat. These ones did not hide their displeasure as they openly resisted him. The second set of enemies was his acquaintances and family members. These people show love to Moses in public but secretly harm him. Unfortunately, Baba Sala only guarded against the external enemies. Being resolute to succeed, he had strategies to overcome whatever his external haters may do. But he trusted every family member, not realising that he was having a romance with his internal enemies.

Like, Baba Sala, everyone has enemies within his own household as well as outside. The enemies to dread are not those who openly declare war against you because they have actually given you notice to prepare. The real enemies to fear are those who appear as friends and laugh with you, because they have plenty of access to your unguarded hours. The reason why it is difficult to overcome the enemies within is because it is very hard to know who they are. It is good to trust and love the family. But knowing well that among members of your beloved family are enemies aiming to pull you down, you must always be on guard when dealing with your friends, the same way you would have taken serious precautions when surrounded by enemies. Beware of your enemies and

also beware of your friends, sometimes both of them have the same evil agenda. That you are surrounded by family does not mean you will be safe. That someone shares the same blood bond with you does not mean he could be trusted. Never let your guard down, even when with friends.

Your talents and passion may take you to prominence, but you need higher management skills to keep yourself in stardom. Attending a business school is a very good step in this regard.

Many of the reasons why Baba Sala needed many wives no longer holds. Polygamy is part of African culture. It was very necessary for our forefathers to have many wives and children so as to get adequate hands to assist them in their farm work. But African culture is not static, it evolves with societal transformation. Most vocations are now professionalised while qualified staff from outside the family can be recruited. But most importantly, 'Orun Mooru' saga shows that maintaining greatness requires even greater efforts than the efforts needed to achieve greatness. Your talents and passion may take you to prominence, but you need higher management skills to keep yourself in stardom. Attending a business school is a very good step in this regard.

But the piracy of 'Orun Mooru' is also a reflection of some of the failures of our society. It should be noted that at the time Baba Sala released 'Orun Mooru', there was no effective government control of rights and access to intellectual property in Nigeria. If there were effective government protection against piracy, maybe Baba Sala would not have suffered so many losses and setbacks in his career. When Baba Sala sought official redress through the court, the case was struck out after three years of non-appearance of the perpetrators in court. Had Baba Sala got help through the court, maybe he would have received some compensation that would have assisted in paying back his bank

loan. Doubtless, Baba Sala's comedy business would have strived better if the owner and those working with him were exposed to better business and financial management skills. If the appropriate government ministry had provided such training to Moses Olaiya, he would definitely have been able to better manage the rest of his businesses and innovations and his bank loans could have been paid without selling his private properties as he did.

One reality of many African settings, especially, Nigeria, is inadequate government support for entrepreneurs. Many businesspersons would have to train themselves, raise financial resources, and provide their own electricity, water and security. Even until now, piracy is very common. The African youth must be prepared to face challenges such as these and must devise means to overcome them in order to be successful. The federal government doubtless had several government programmes targeted at promoting the small and medium scale enterprises, but inadequate social infrastructures such as good roads and electricity as well as ineffective protection against piracy are persisting problems.

CHAPTER NINE

RISING AGAIN

Heroes are not people who have not fallen before. Instead, they are people who, after falling, rose quickly and continued their exploit making. Despite the fact that the piracy of 'Orun Mooru' gave Moses Olaiya a huge financial setback, the challenges did not stop the hero in him. Baba Sala rose up again; he put his disappointments behind him and continued to make Nigerians happy with his humour. 'Orun Mooru' was Baba Sala's first film and the challenges he faced as a result of that film were sufficient to make anyone stop film production. But Baba Sala did not allow 'Orun Mooru' to write the last chapter of his life. Instead, he persevered and produced many more plays and films, including Aare Agbaye, Mosebolatan, Obe Gbona, Diamond, Agba Man, Return Match Ana Gomina, and Money power to mention a few.

No challenge is strong enough to stop the greatness in you if you are not discouraged. This is because the abilities and talents that make people great are inbuilt. Your talents are kept inside you so that no external difficulty can destroy it. No poverty or failure or disappointment is strong enough to kill the treasure of greatness in you. If you can continue to do what you believe you are created to do, no matter the odds, you will win. Even though no external challenges can stop your abilities, challenges can cause

discouragement that will make you change your mind from pursuing your goals. Discouragement is a great enemy.

Discouragement is the worst enemy of man because it is an attack launched against you from within yourself, thereby making you the enemy of yourself. Discouragement is an internal conviction of the one million reasons why you should call it quits. Discouragement makes you blind to God's goodness to you and magnifies the negative experiences around you. Discouragement brings hopelessness and depression, it will gradually reduce the speed of a man until he is brought to a permanent halt.

No challenge is strong enough to stop the

greatness in you if you are not discouraged.

It is worthy to mention that Baba Sala's resilience and consistency despite his huge loss was the fortification that made comedy in Nigeria a strong industry today. Baba Sala's perseverance may not lead to any outstanding financial breakthrough for him. However, his tenacity created ground-breaking opportunities for operators in the entertainment industry. Baba Sala's relentless efforts to bounce back created and expanded the market for laughter or comedy as a product. It became a huge demand which Moses Olaiya alone could not meet. The demand for comedy offered great opportunities for those with humour talents to profitably use their gifts. Initially, most of the comedians imitate Baba Sala, especially in their appearance and gestures.

Discouragement is the worst enemy of man because it is an attack launched against you from within yourself, thereby making you the enemy of yourself.

However, over the years, many comedians have been able to sat-

isfy their audience without dressing like a clown. Comedy in Nigeria has also evolved with stand-up comedians making wave. Today, comedians in Nigeria are respected and celebrated professionals and they have ready market for their jokes. The efforts of Moses Olaiya Adejumo in making this possible can never be forgotten. Comedy profession offers employment opportunities for talented youths while government also generates tax income from entertainers. Baba Sala's impacts are thus transgenerational and across all boards.

In conclusion, greatness is more than making money. Greatness is about making impacts that touch many lives. In recognition of his great work, Moses Olaiya Adejumo received many national and international awards including the conferment of the award of Member of the Order of the Niger [MON] by the federal government of Nigeria. On Sunday 7th October 2018, Moses Olaiya Adejumo died in his house at the age of 81 years. Although Moses Olaiya is late, his legacy lives on. If you pursue goals that shall be a blessing that has the potentials to bless generations yet unborn, then, you are likely going to be one of the most influential people who ever lived!

greatness is more than making money. Greatness is about making impacts that touch many lives.

www.ingramcontent.com/pod-product-compliance
Lightning Source LLC
Chambersburg PA
CBHW030734180526
45157CB00008BA/3158